The
PERFECT ESCAPE

The
PERFECT ESCAPE

An Adventure into the Whimsical
and Odd World of Cheryl Church

CHERYL CHURCH

iUniverse®

THE PERFECT ESCAPE
AN ADVENTURE INTO THE WHIMSICAL AND ODD WORLD OF CHERYL CHURCH

iUniverse books may be ordered through booksellers or by contacting:

iUniverse
1663 Liberty Drive
Bloomington, IN 47403
www.iuniverse.com
1-800-Authors (1-800-288-4677)

Because of the dynamic nature of the Internet, any web addresses or links contained in this book may have changed since publication and may no longer be valid. The views expressed in this work are solely those of the author and do not necessarily reflect the views of the publisher, and the publisher hereby disclaims any responsibility for them.

Any people depicted in stock imagery provided by Thinkstock are models,
and such images are being used for illustrative purposes only.
Certain stock imagery © Thinkstock.

ISBN: 978-1-4917-9857-7 (sc)
ISBN: 978-1-4917-9858-4 (e)

Library of Congress Control Number: 2016909774

Print information available on the last page.

iUniverse rev. date: 07/11/2016

"The Perfect Escape"

The purpose of art is washing the dust of daily life off our souls ~ Pablo Picasso

Often times we artist run into a painters block just as the writers of amazing stories hit writer's block. Artist minds become at ease when we create. If we lose our "mojo" we have a tendency to be grouchy as my husband says. When I hit those points of blockage I look into other avenues to still remain creative. I turn to my sketchbook and take an old drawing, refurbishing it into something new or I may just take one of those sketches and color it bringing it to life through colored markers pens and coloring pencils. I have created this book using my sketches in my sketchbook so that you too may bridge back over to the creative side, drenching the dry spell into color and life. Everyone needs to cleanse their souls at some point in life. We all have a little artistic side that can take a contour line drawing and make it come alive through colors of choice. I sincerely hope that you "dust yourself off" through coloring of my Perfect Escape.

Cheryl Church 6824 C. L. 94, Carthage, MO. 64836, www.cherylchurch.com, savingchurch@gmail.com

A special thanks to my husband Kyle and my daughters Ashley and Bryanna. Without their encouragement and patience and doing lots of dishes for me, I would not have completed this endeavor.

"The Wise and the Strong"

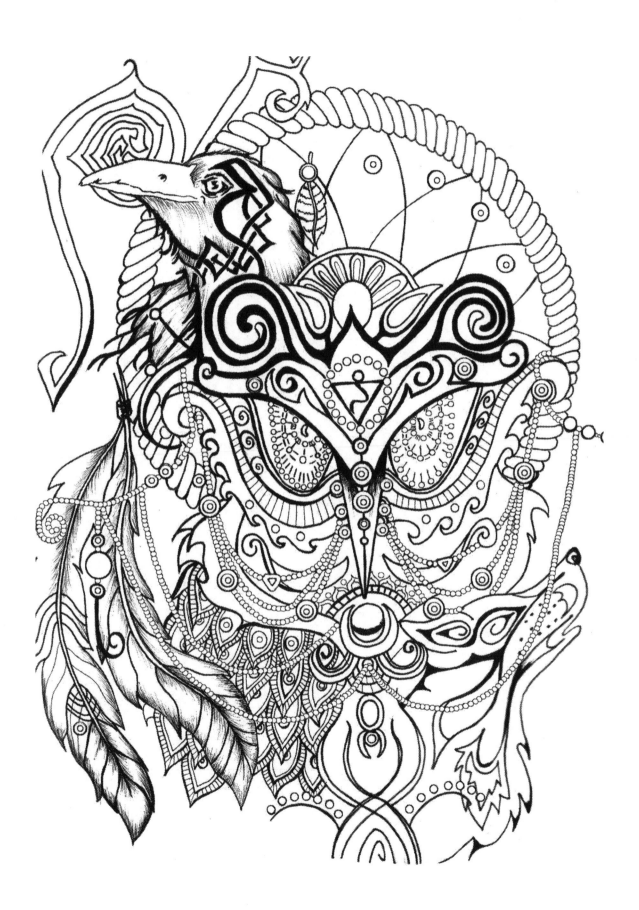

"True Seeing"

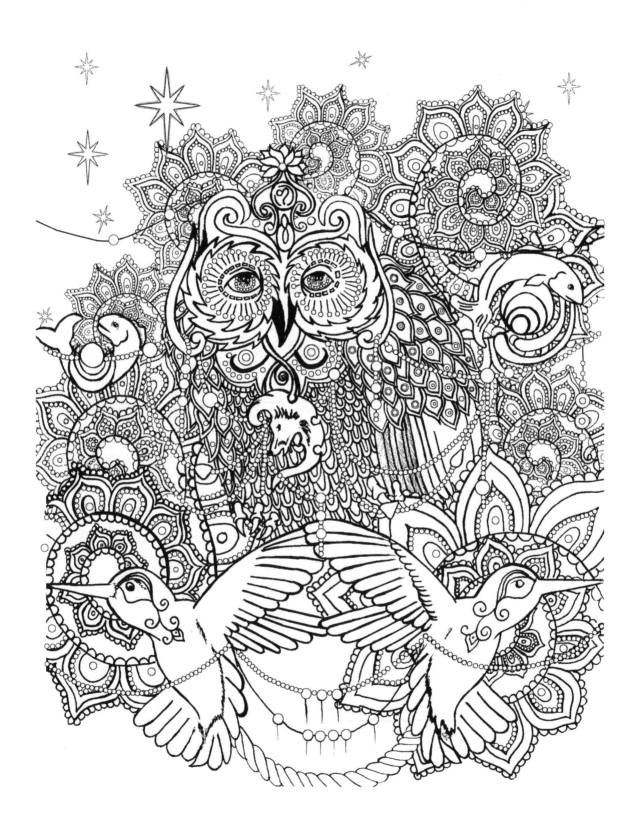

"The Provider"

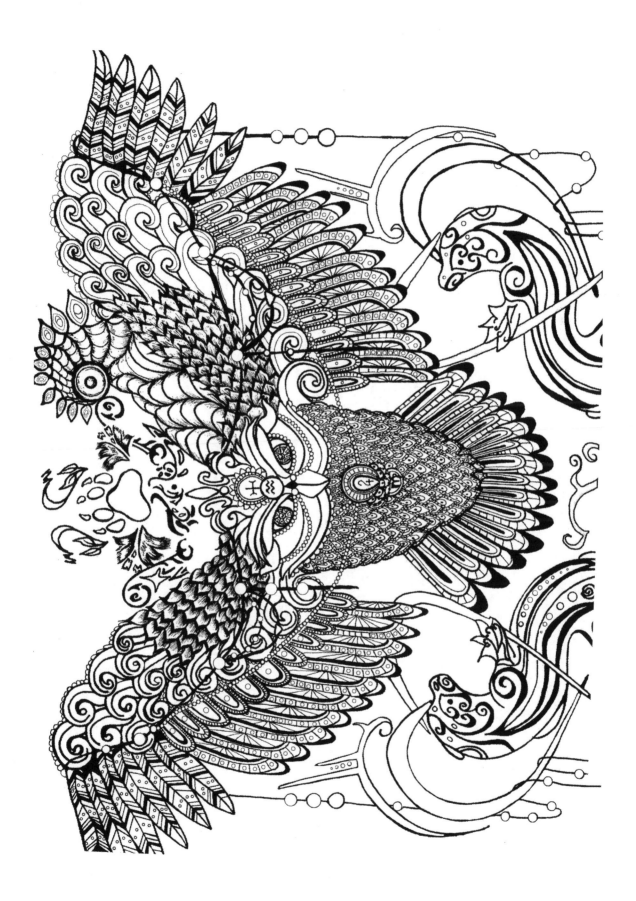

"Julia's Dream"

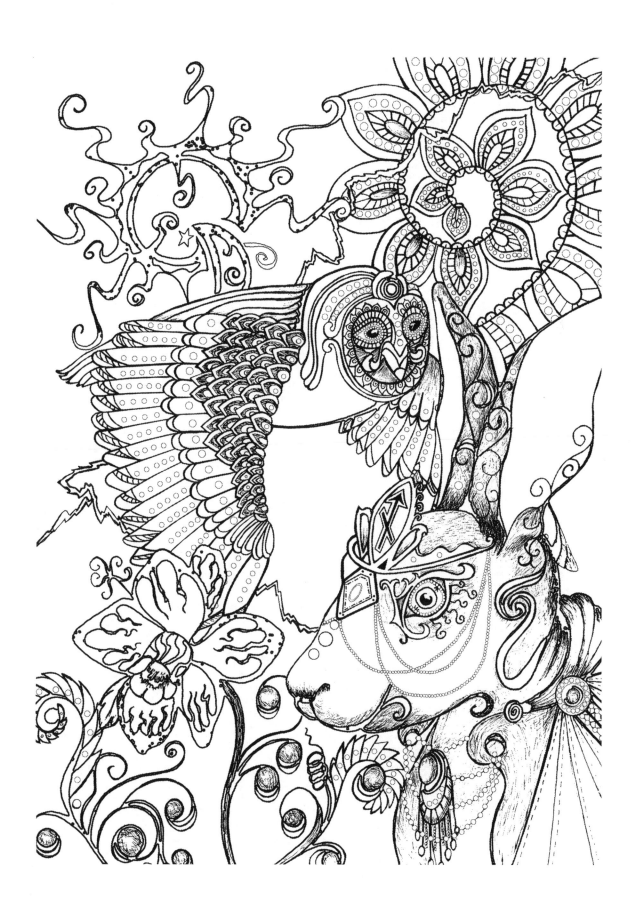

"Guarding Life"

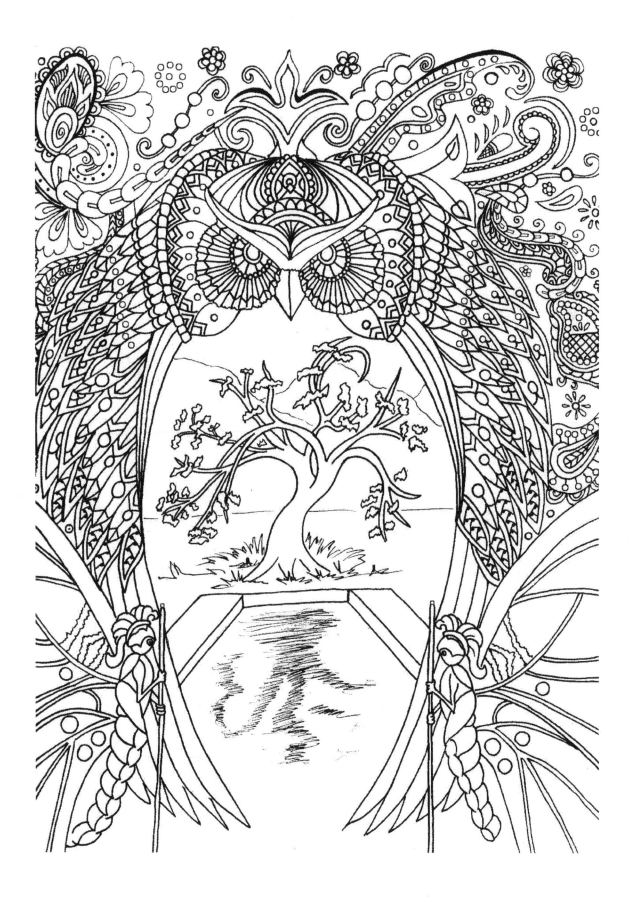

"Nature's Strength"

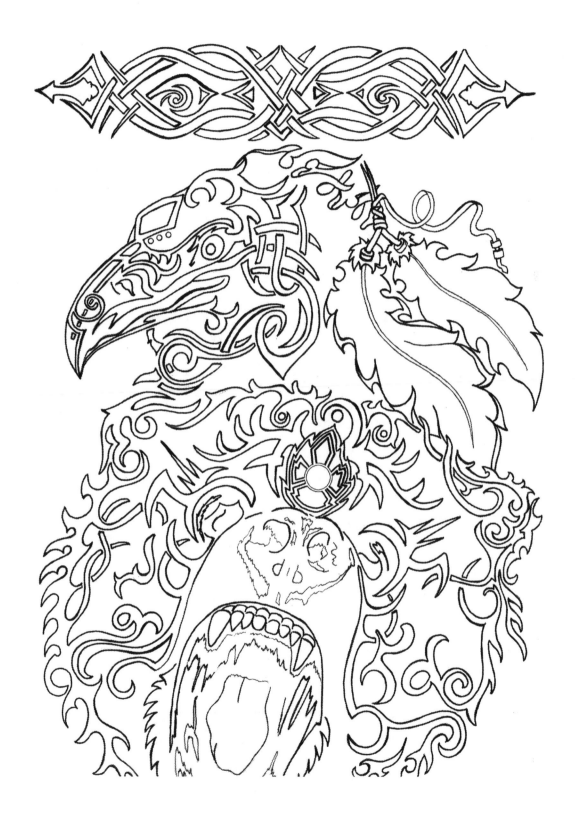

"Tales of the Isaac"

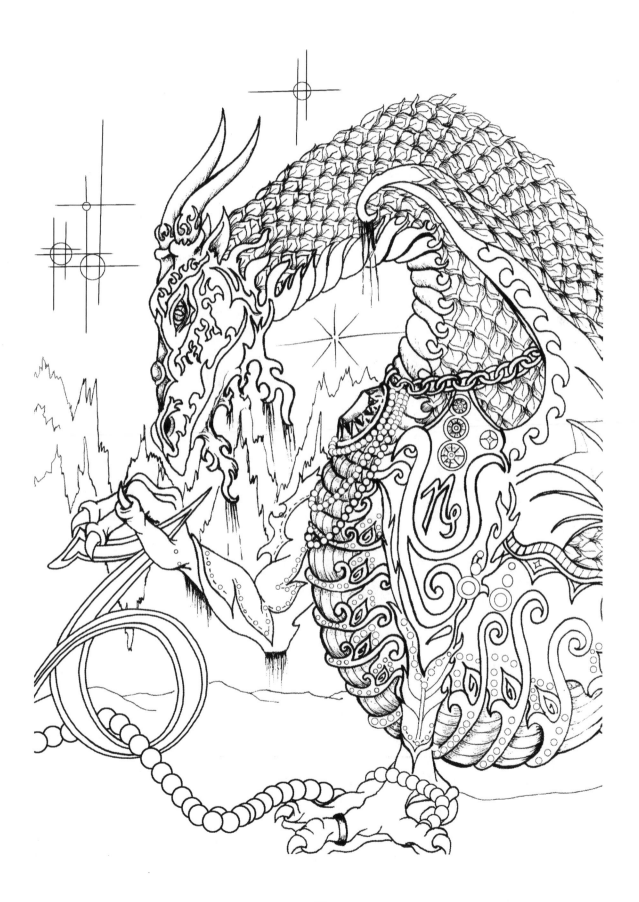

"Georgia Swamp"

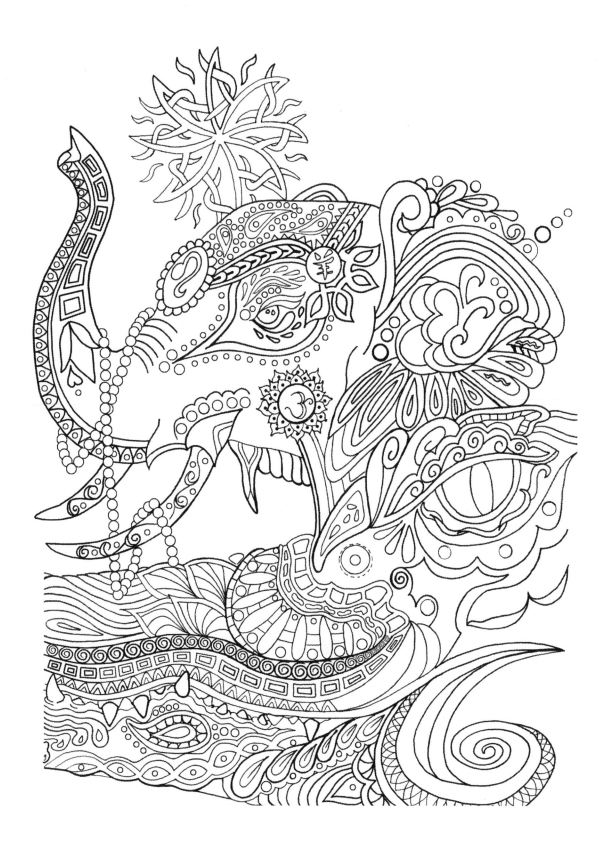

"Protectors of the Young"

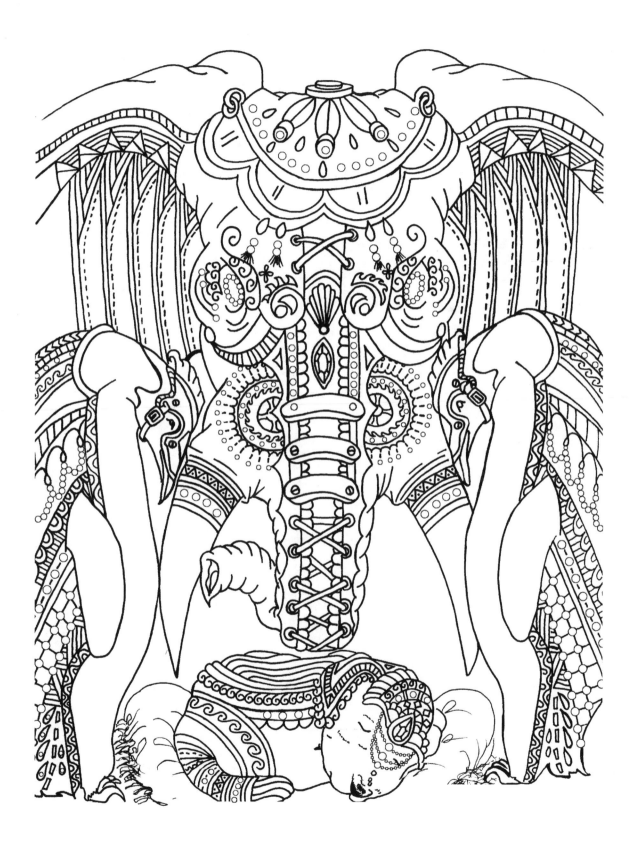

"The Jay-Hawk Connection"
Cancer the crab

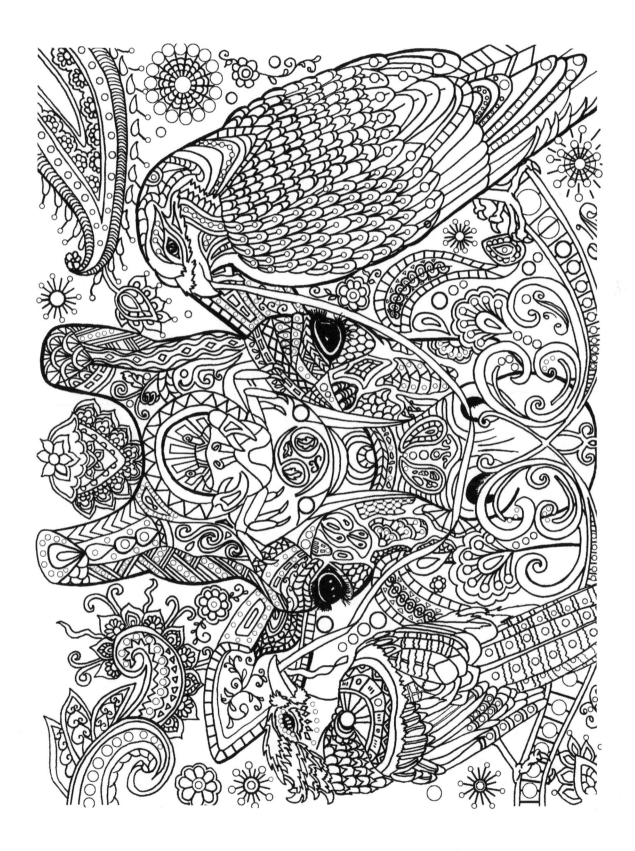

"Leo the Lion"

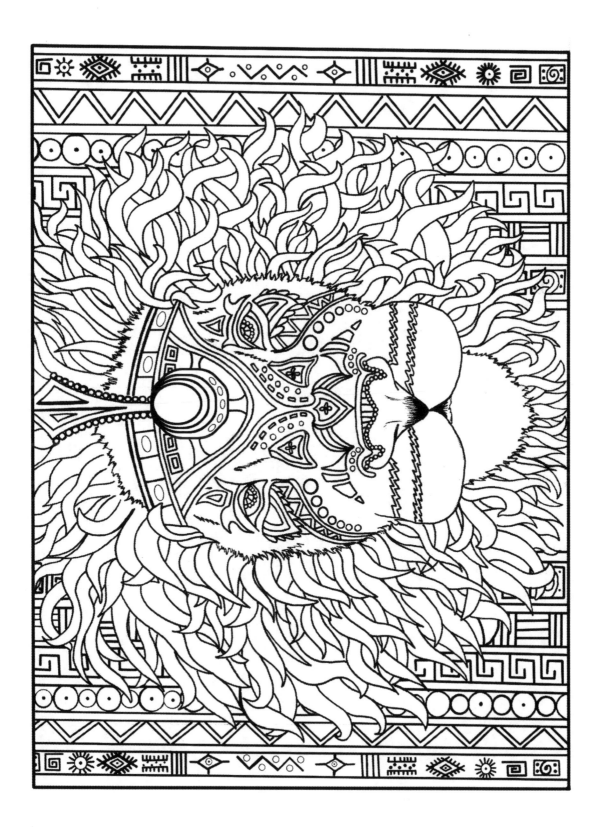

"Nineteen Birds"

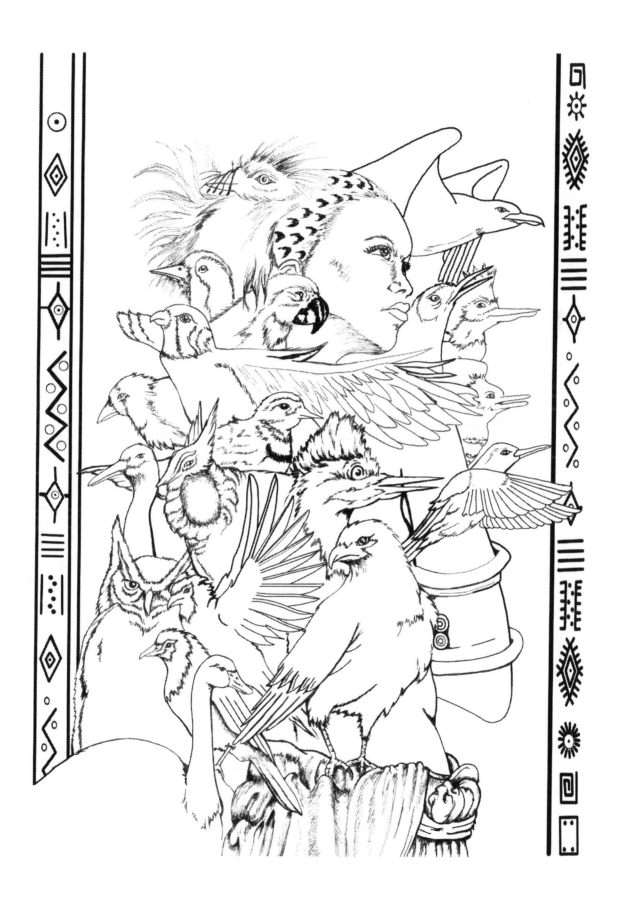

"Luke Two Hawk"

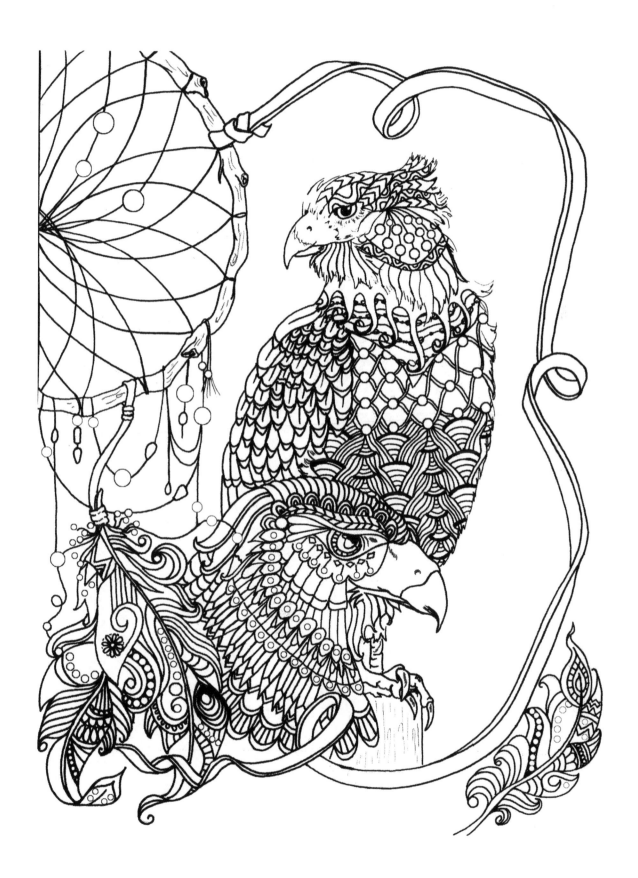

"Safari"

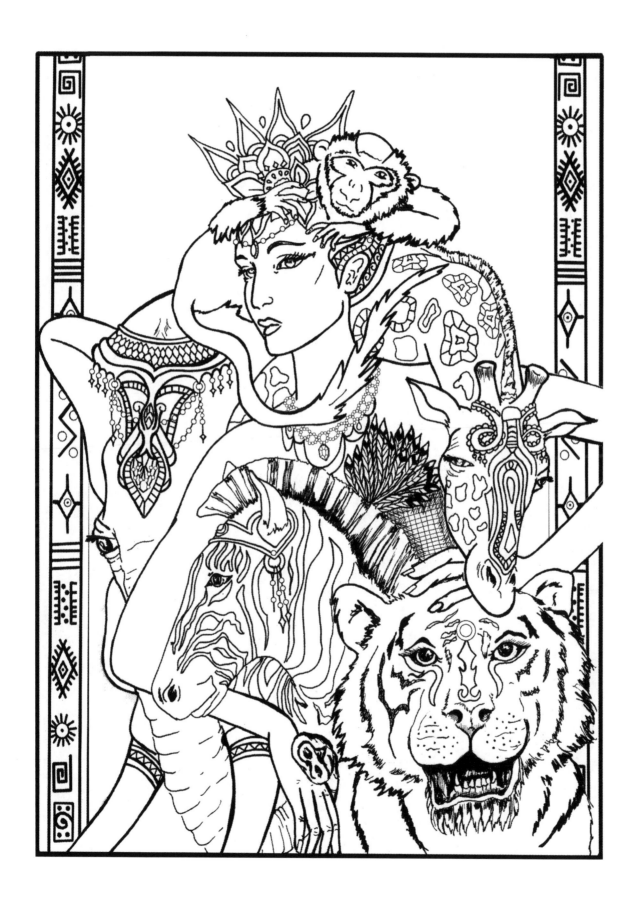

"Floral Fantasy"

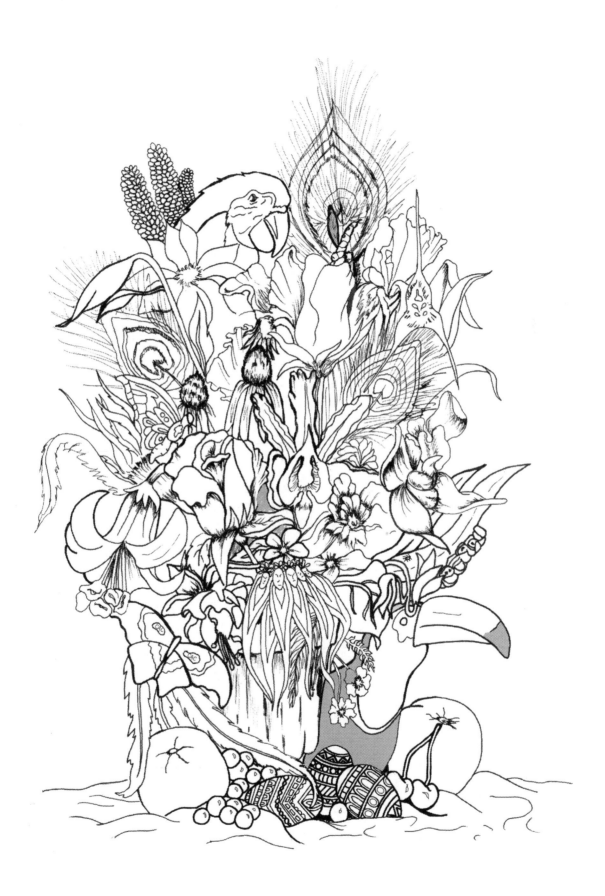

"When Words Fail Museum Speaks"

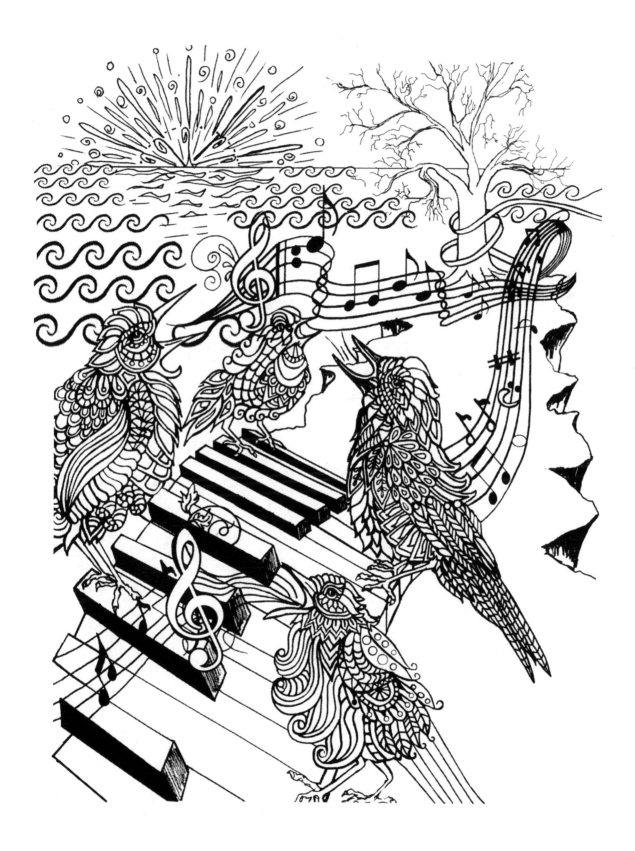

"Fantasia's Queen"

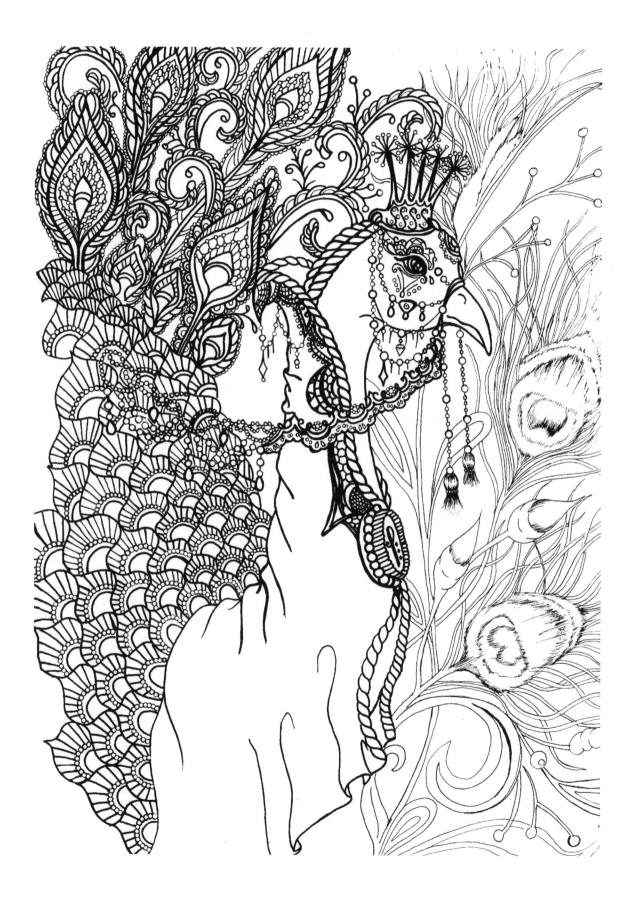

"Transformation"

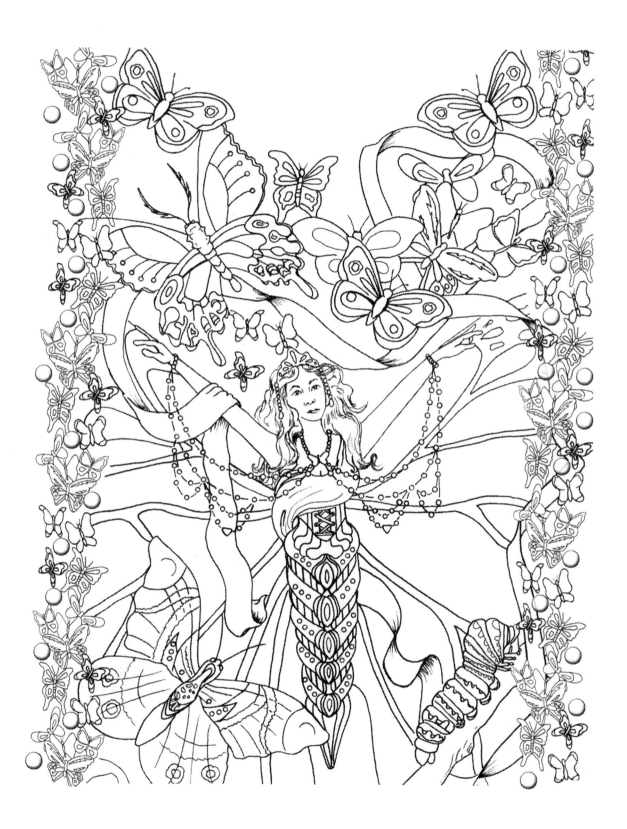

"Channeling Carmen Miranda"

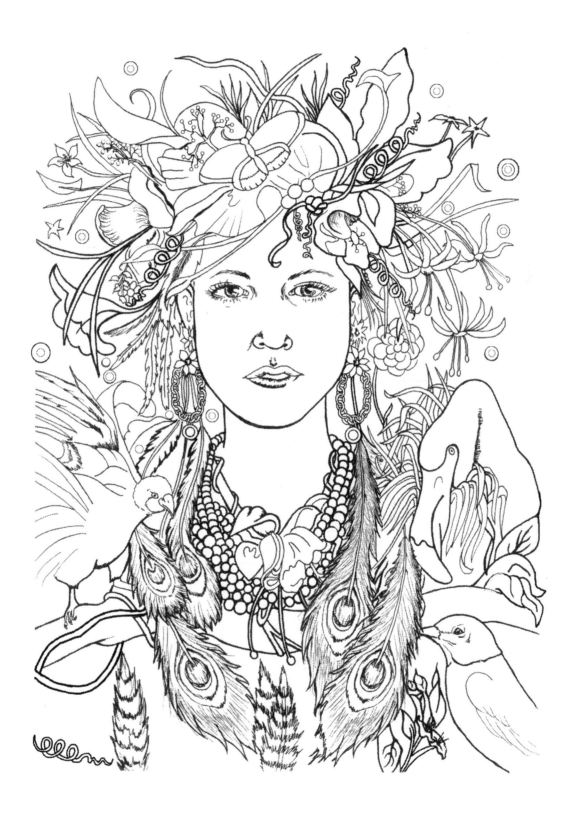

"Athena"

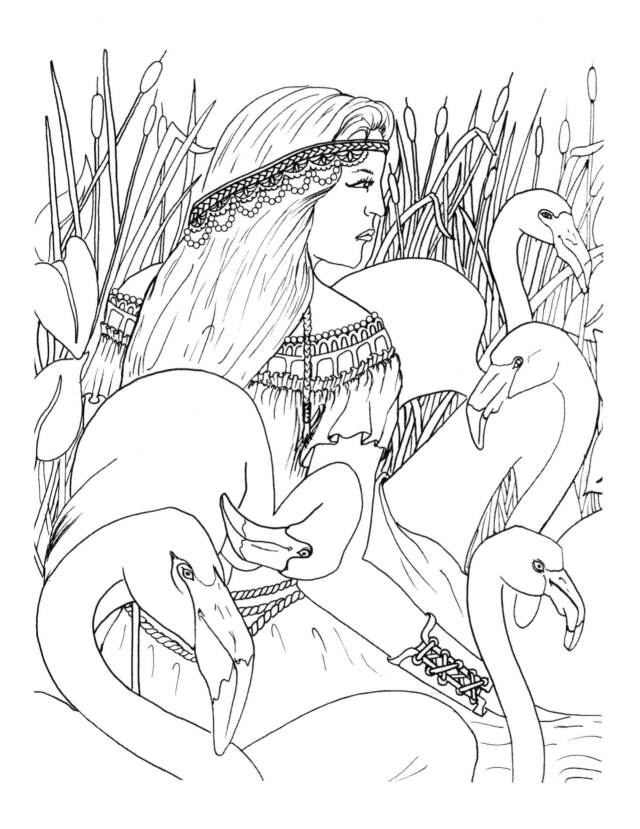

"Time Traveler"

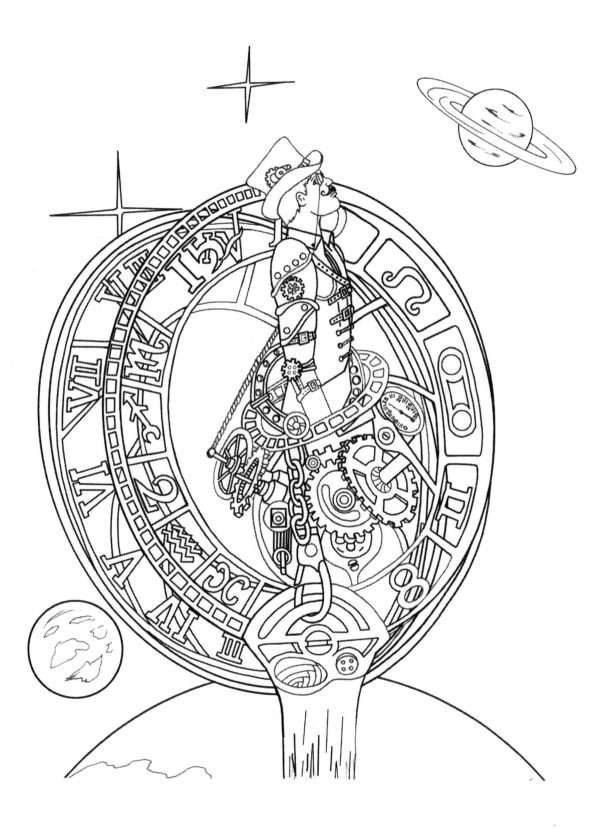

"Chains of Time"

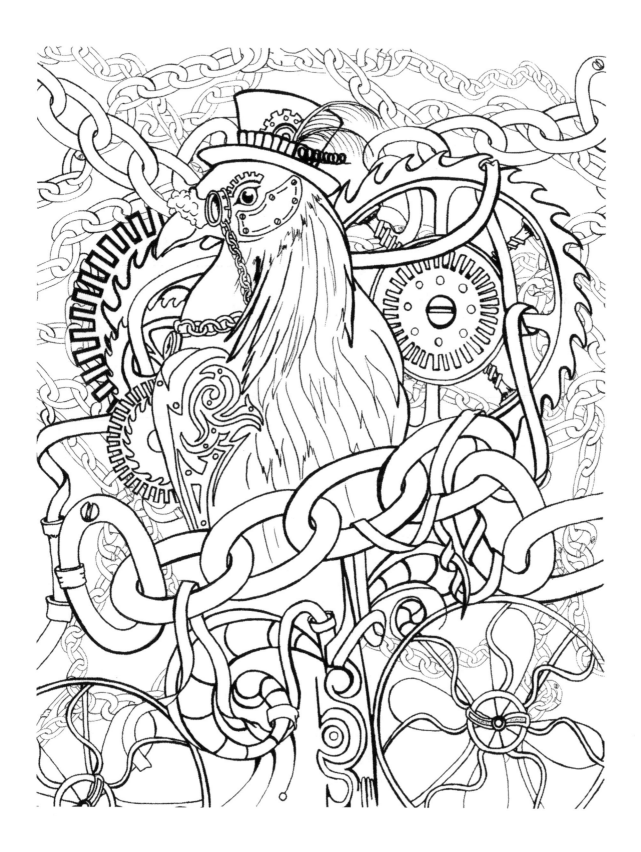

"The Majestic Beast"

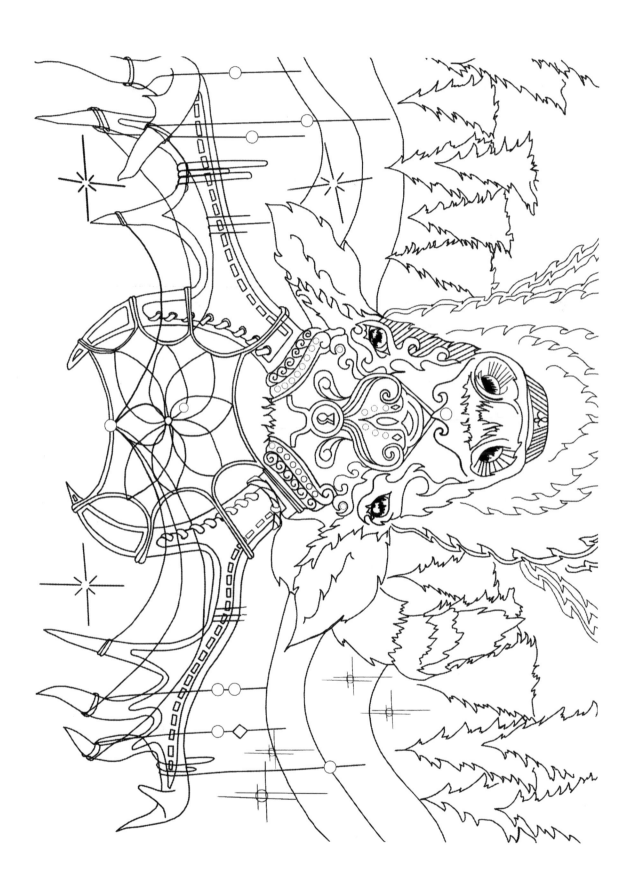

"Aquatic Beauty"

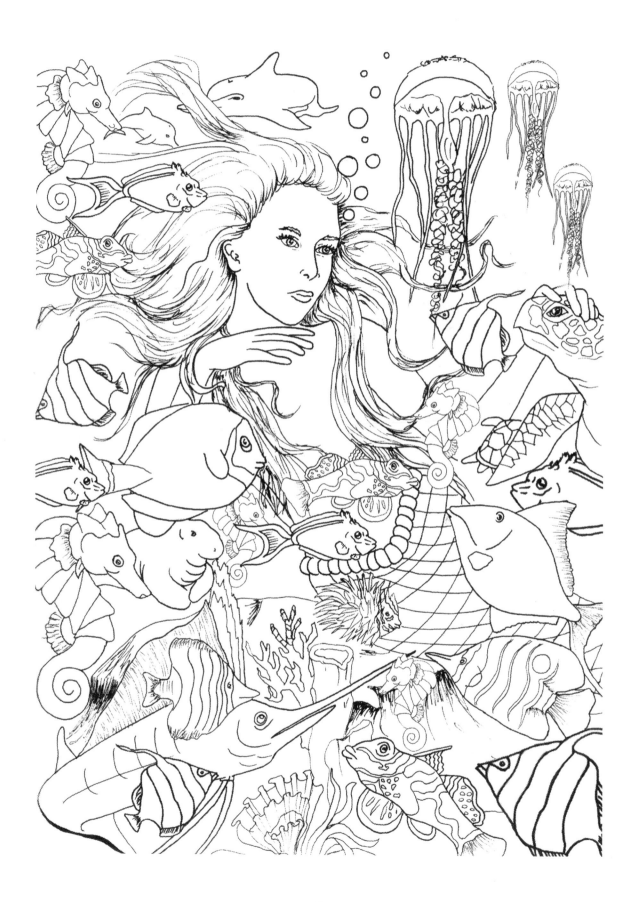

"Dragon Fly"

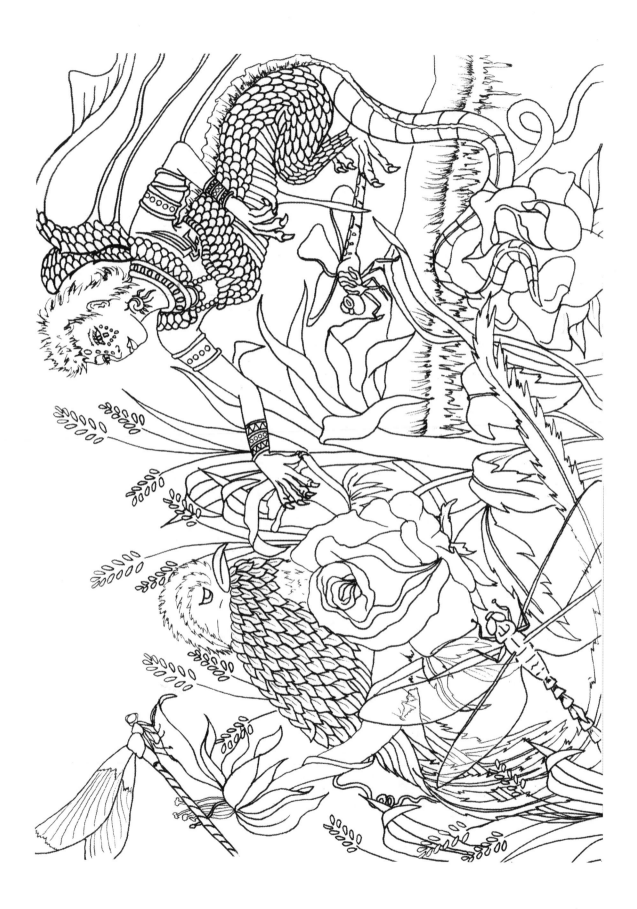